FUCK OFF,
I'M STILL COLORING

Relax with 50 Defiantly Fun
Swear Word Coloring Pages

DARE YOU

STAMP CO.

IF you're reading this, you're our kind of motherfucker. Or you just might be a fan of Dare You Stamp Co. already. And why wouldn't you be? We're awesome. Our line of completely irreverent products is perfect for sticking it to the man and flipping off your haters with style.

Whether you signed your vacation request with our *F This Shit Stamp Kit*, told Santa where he can shove his coal with our *Tis the Season to Be Naughty Postcards*, or became the antihero of your dreams with our *POW! Stamp Kit*, you know we're done being polite. So why not tell the world to fuck off? Break out that pack of crayons you abandoned in middle school and color the fuck out of any number of these swear-filled pages. Frame them, hang them, or leave them all over your boss's desk with your resignation letter stapled to the back. What you do with these are up to you, dumbass. If you feel like showing off, share your fucking awesome creations with the hashtag #fuckoffimcoloring.

Now go forth and be the complete asshole you were meant to be, we dare you.

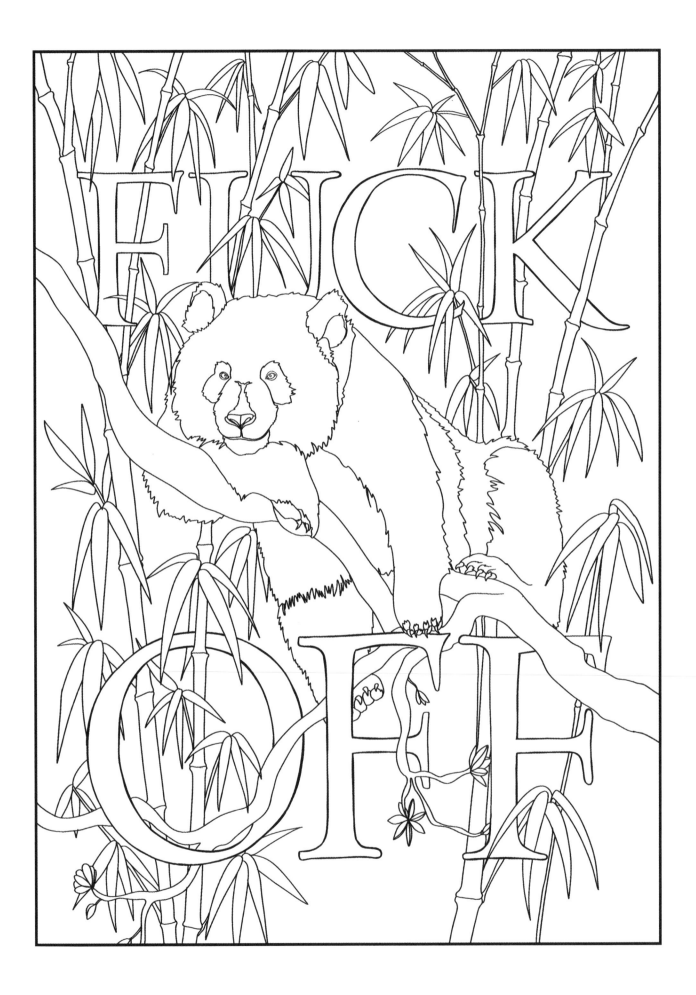

TABLE *of* CONTENTS

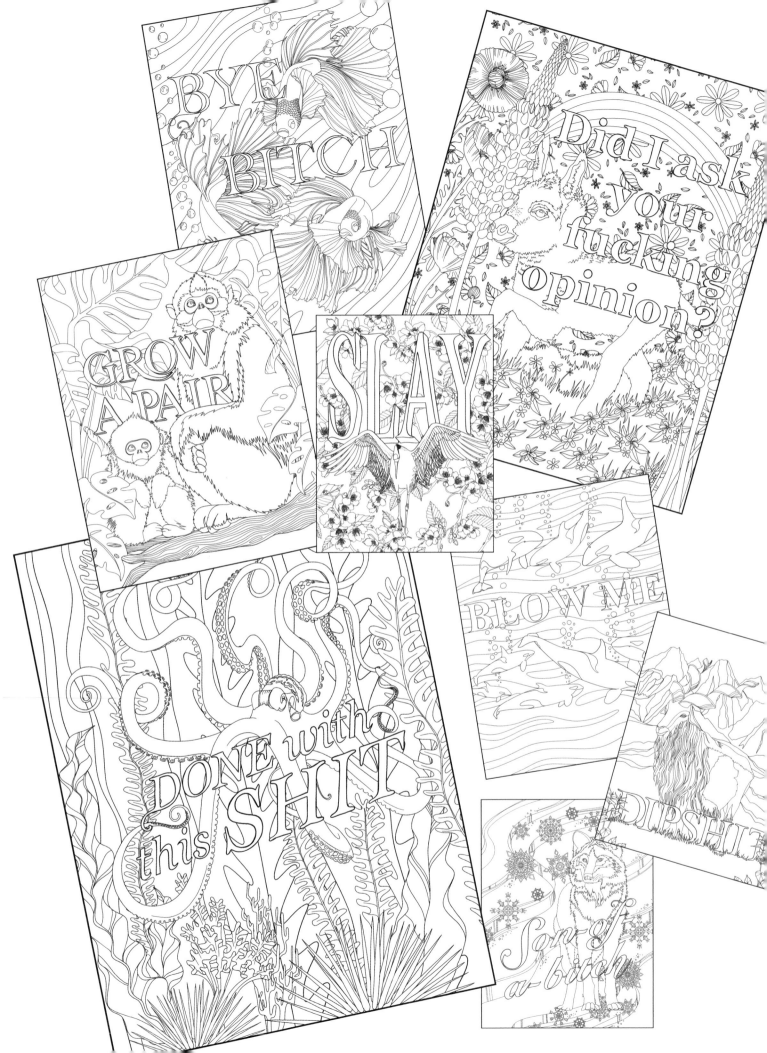

INTRODUCTION

We get it: coloring books are supposed to de-stress people. But we're all adults here, and sometimes you just need to show everyone how pissed off you are at everything. What can we say? The world fucking sucks most days. Which is why you should sharpen your colored pencils and pitchforks and stick it to anyone who thinks they're better than you. Decorate your page of choice to the nines to tell anyone and everyone that they messed up by fucking with you, or give a page to your favorite foul-mouthed cheerleader to thank them for always being there when you need their swear-laced wisdom. The choice is yours.

The uses for these pages are only limited by your (we assume) filthy imagination. Use them to start a protest, quit a job, or let your insurance company know how you really feel about their coverage policy. We won't judge. Hell, we'll cheer you on; we're not responsible for what you do. And once you feel vindicated for how awful life is, flip over to the **#Winning** pages to relish just how sweet victory can be. Feel like people should appreciate you more? **Bitch, I'm a Treasure** has motivational phrases for when you're on top of your slay game so you can remind everyone you deserve some fucking respect.

So rather than filtering all of your rage through Twitter, pull out your pencils and get to work. These pages won't color themselves.

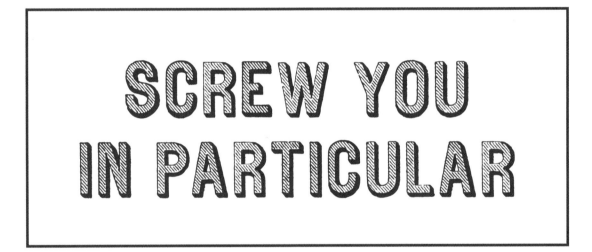

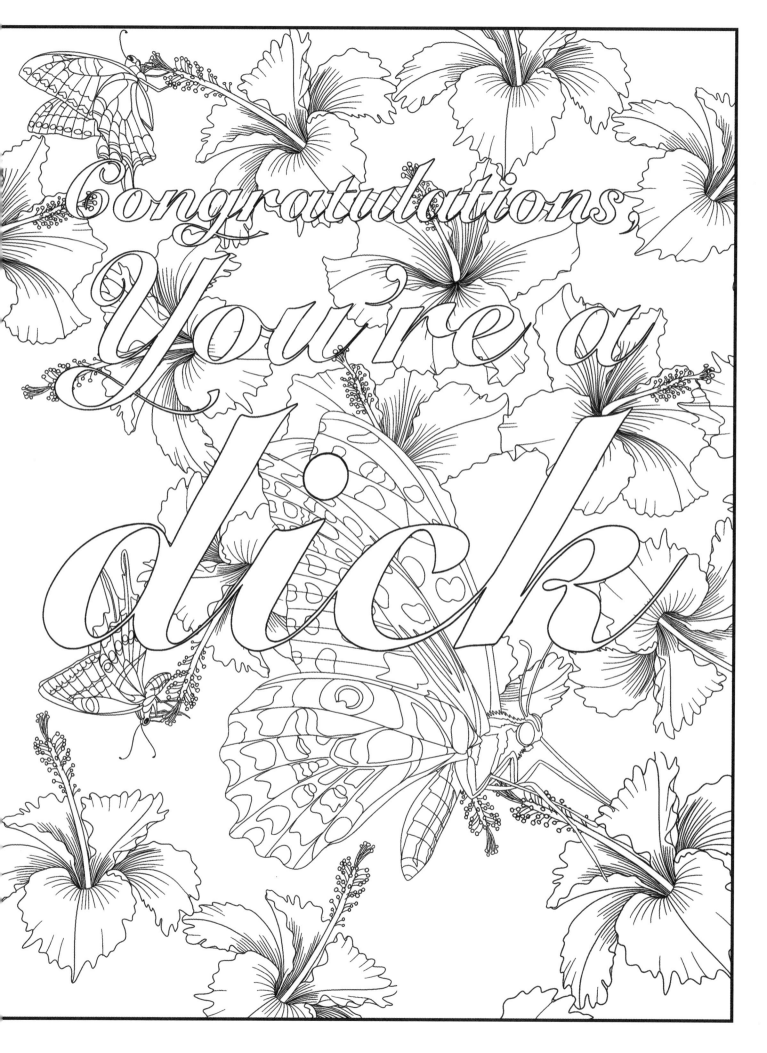

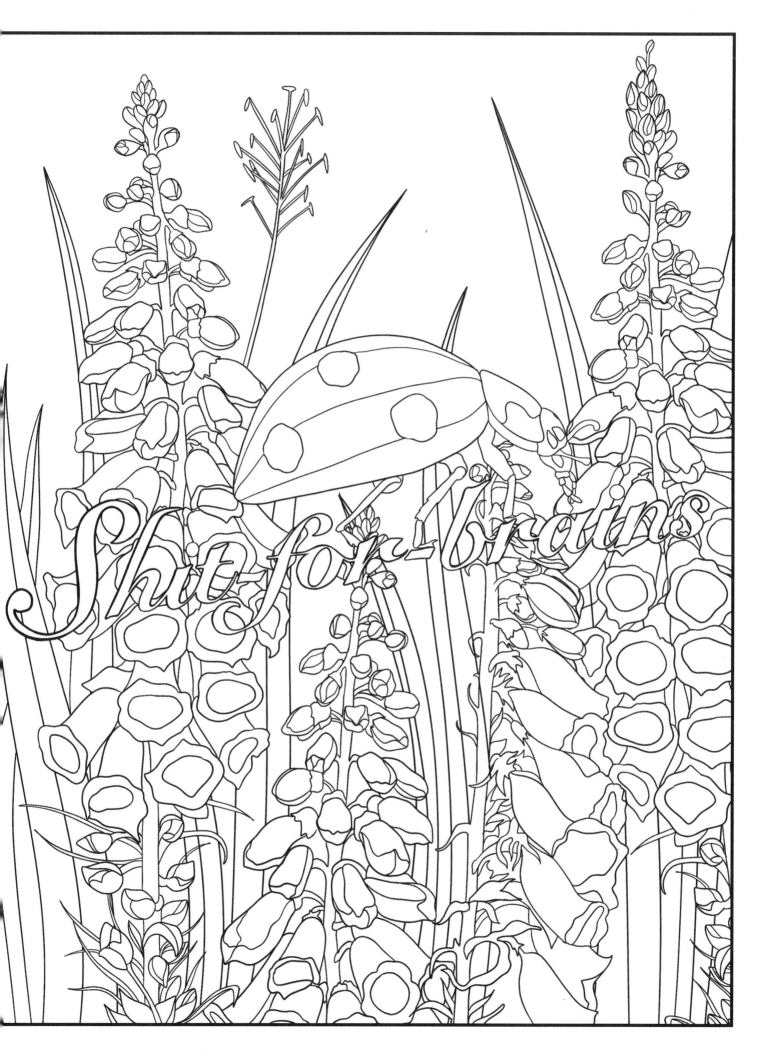

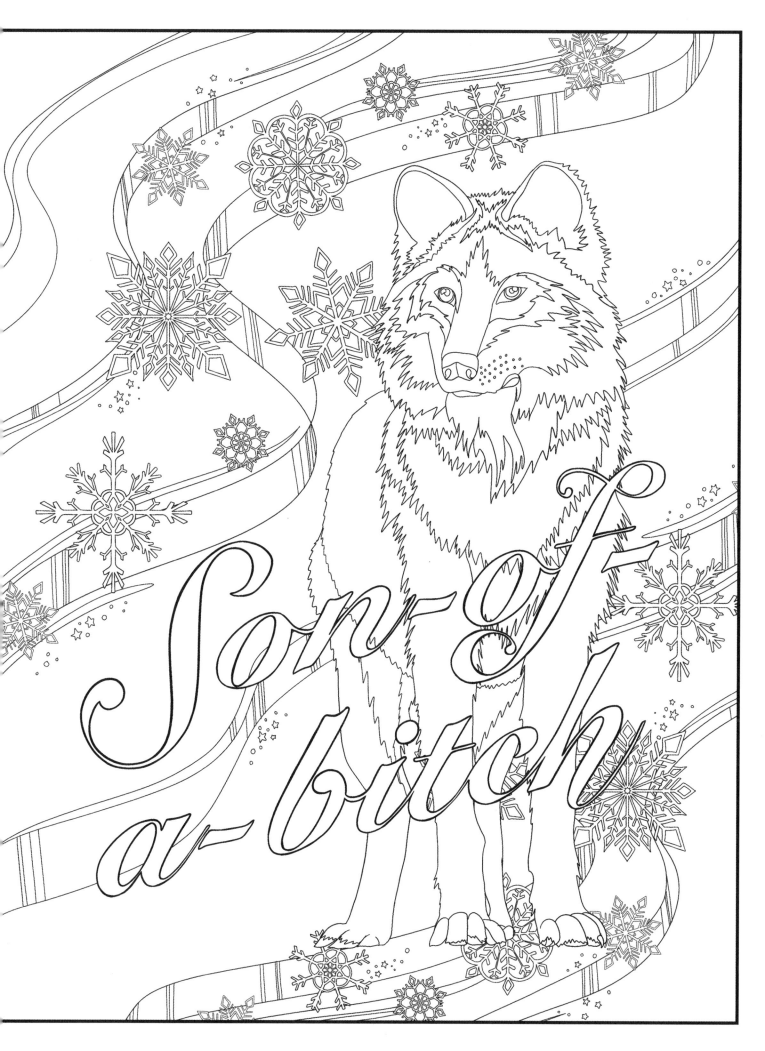

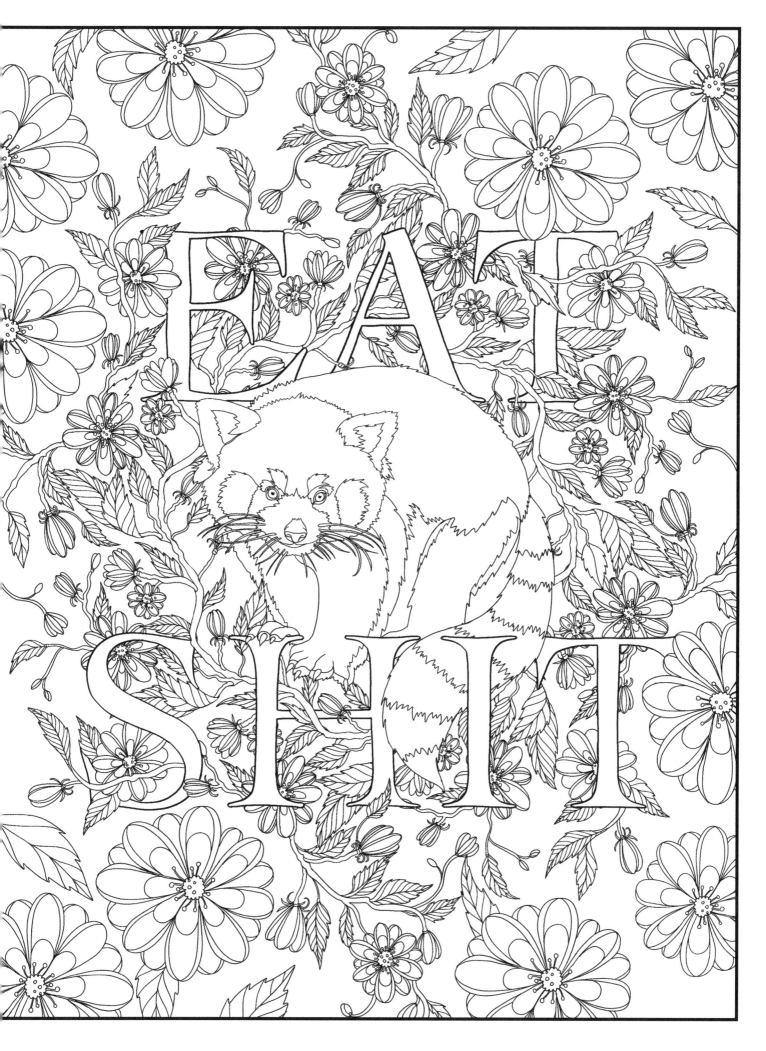

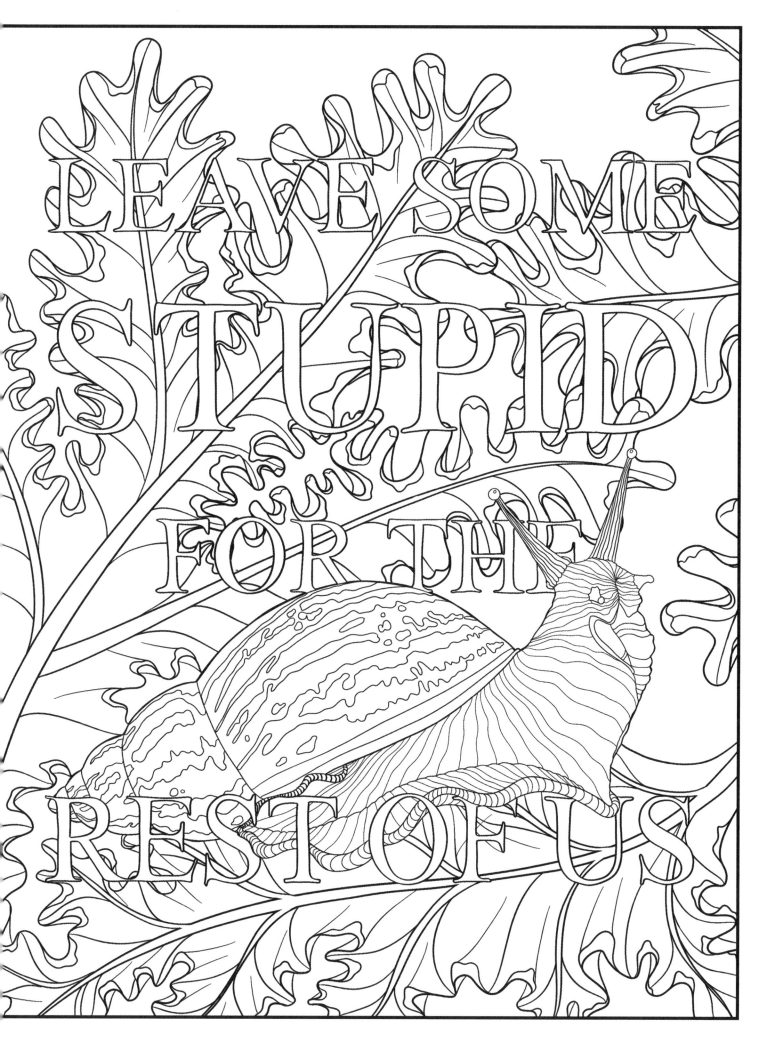

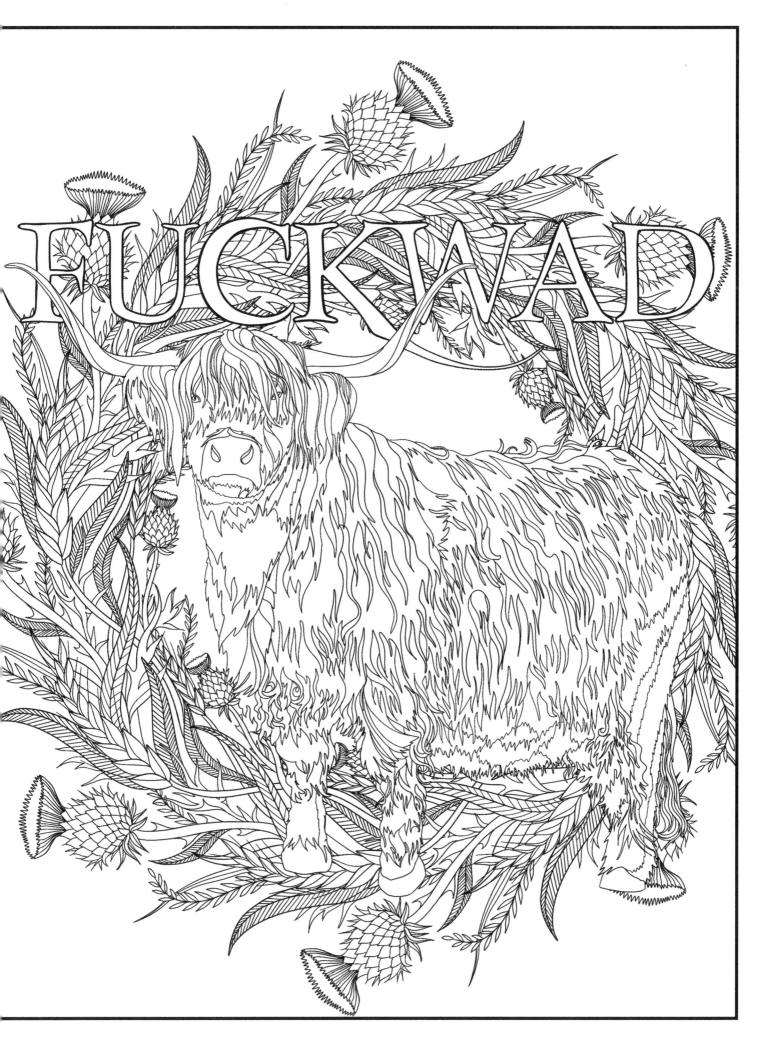

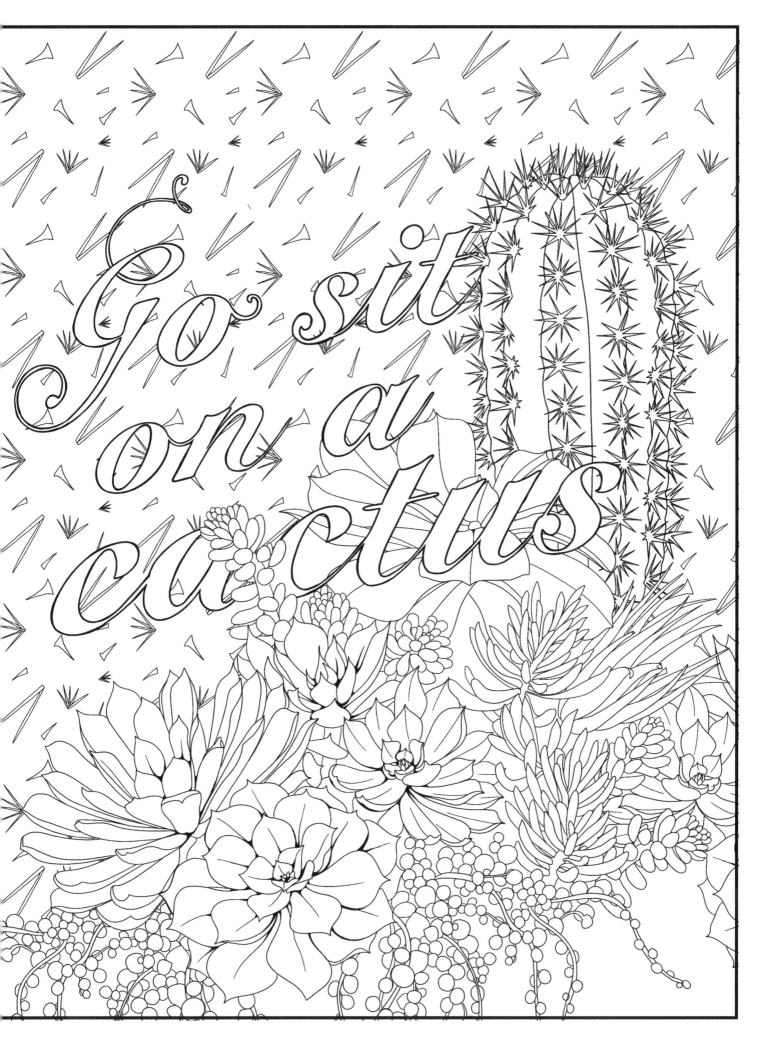

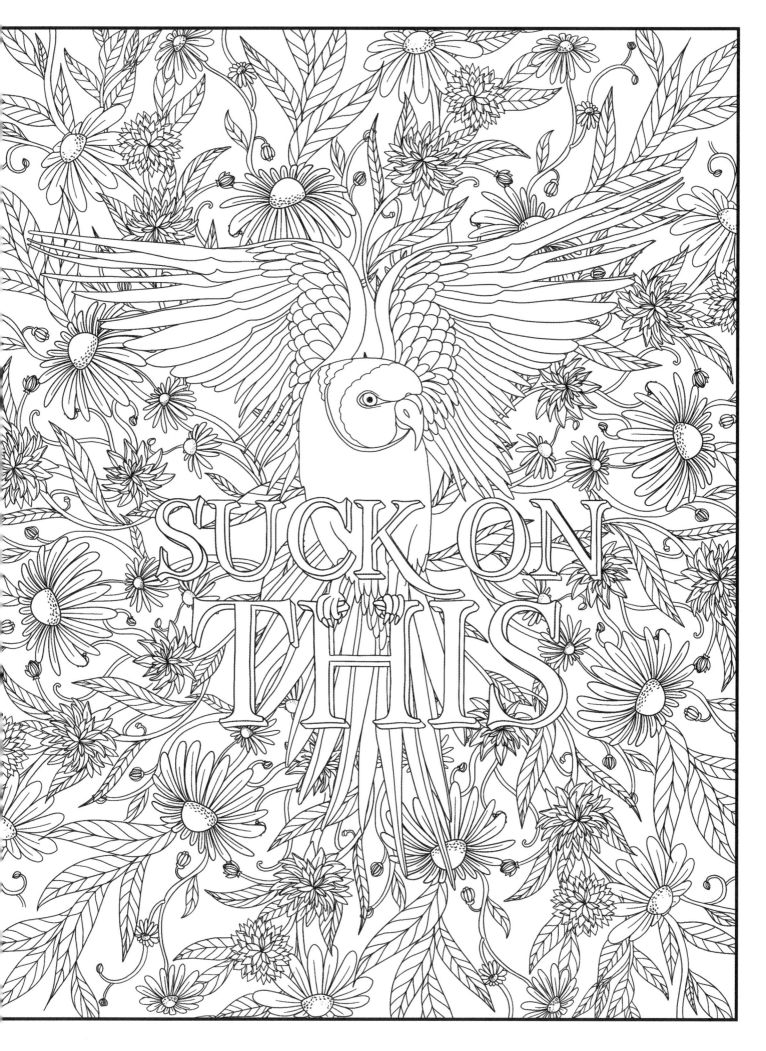

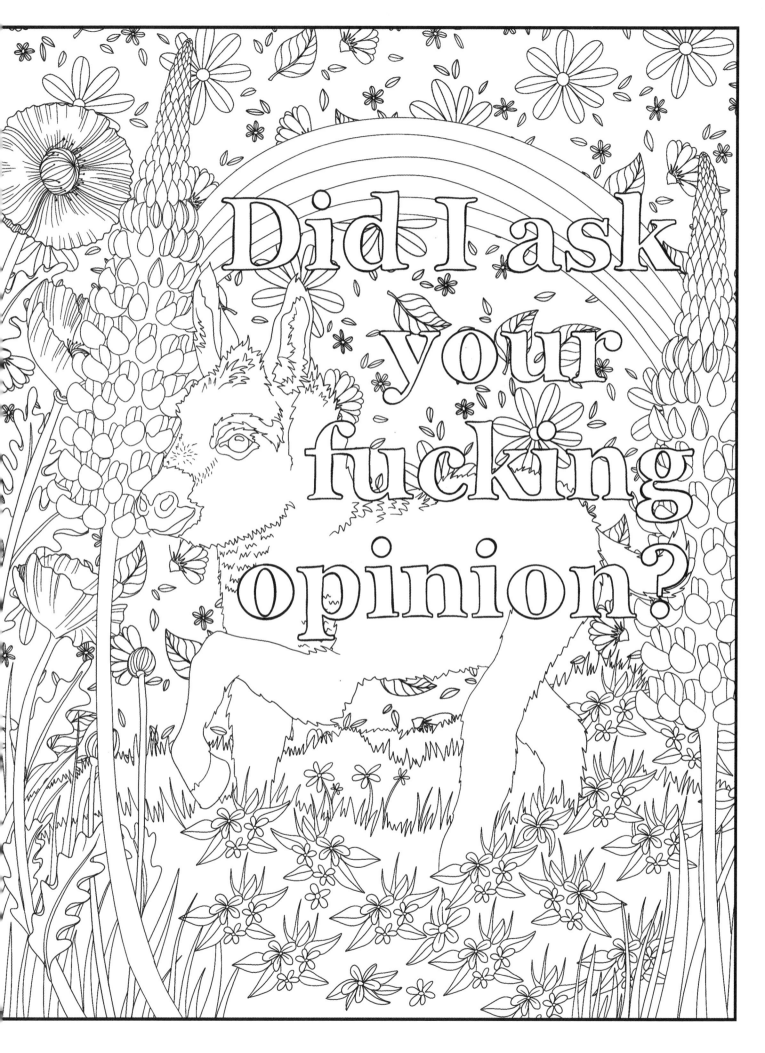

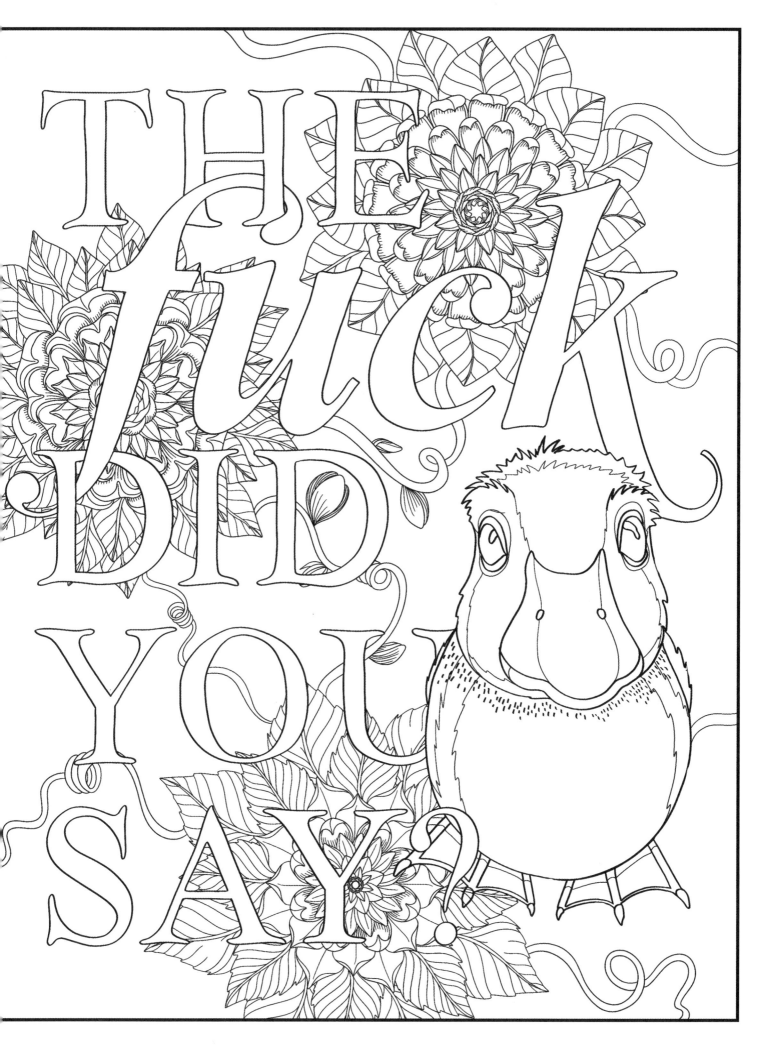

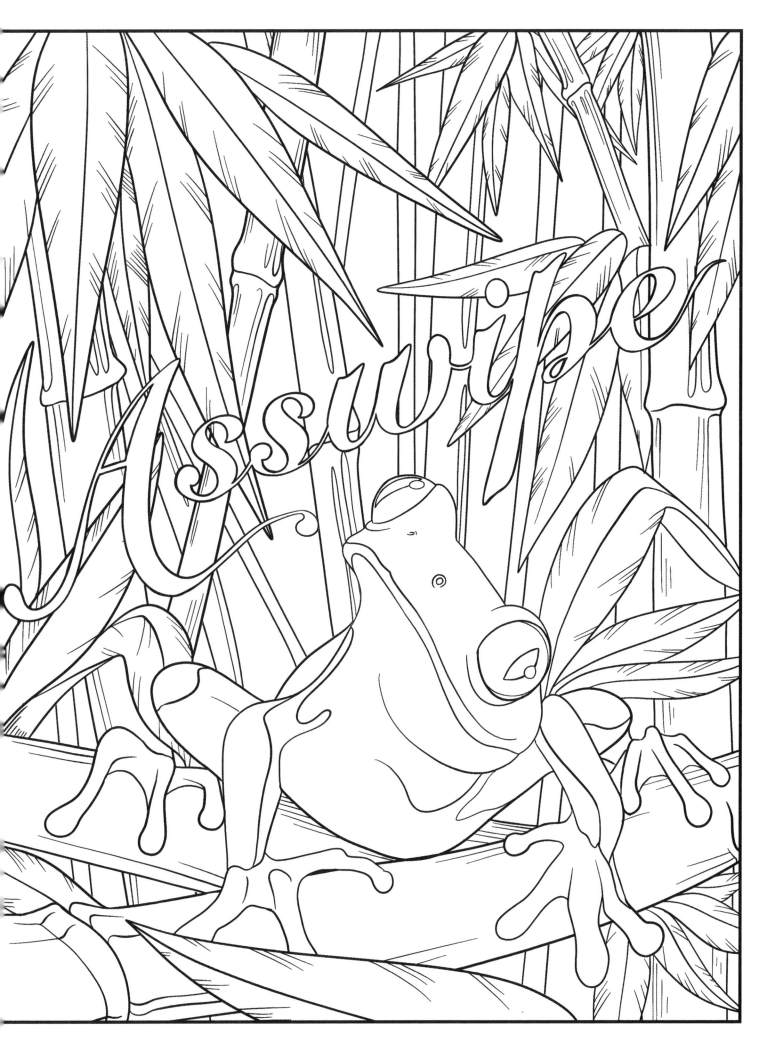

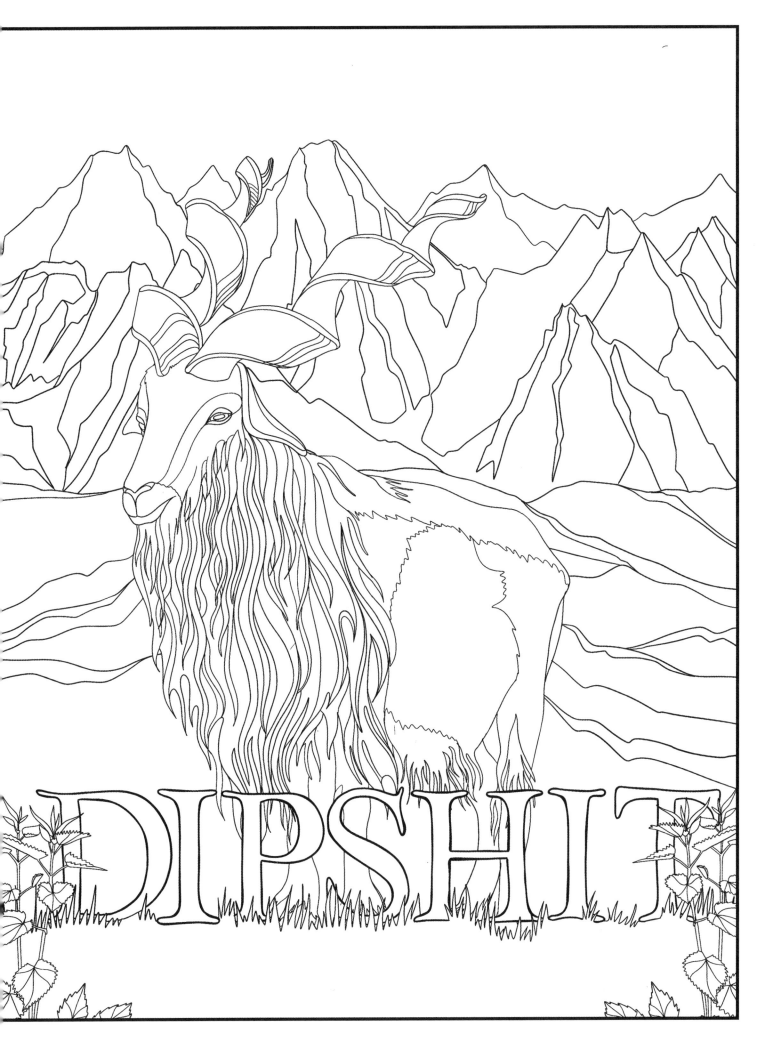

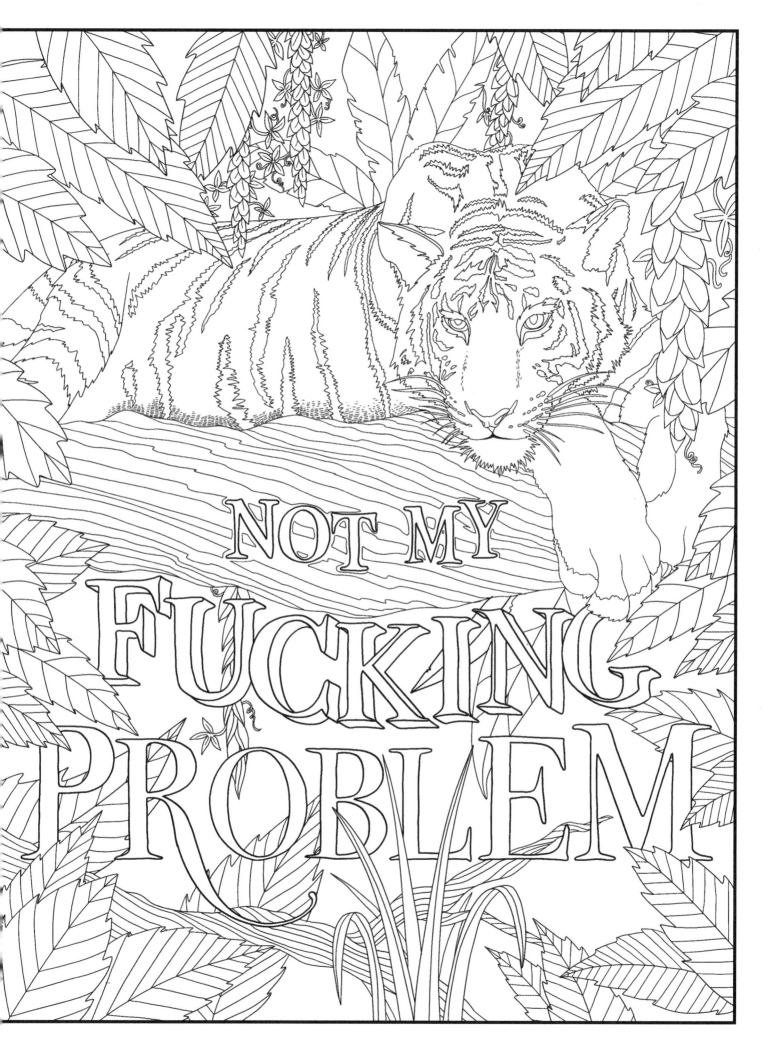

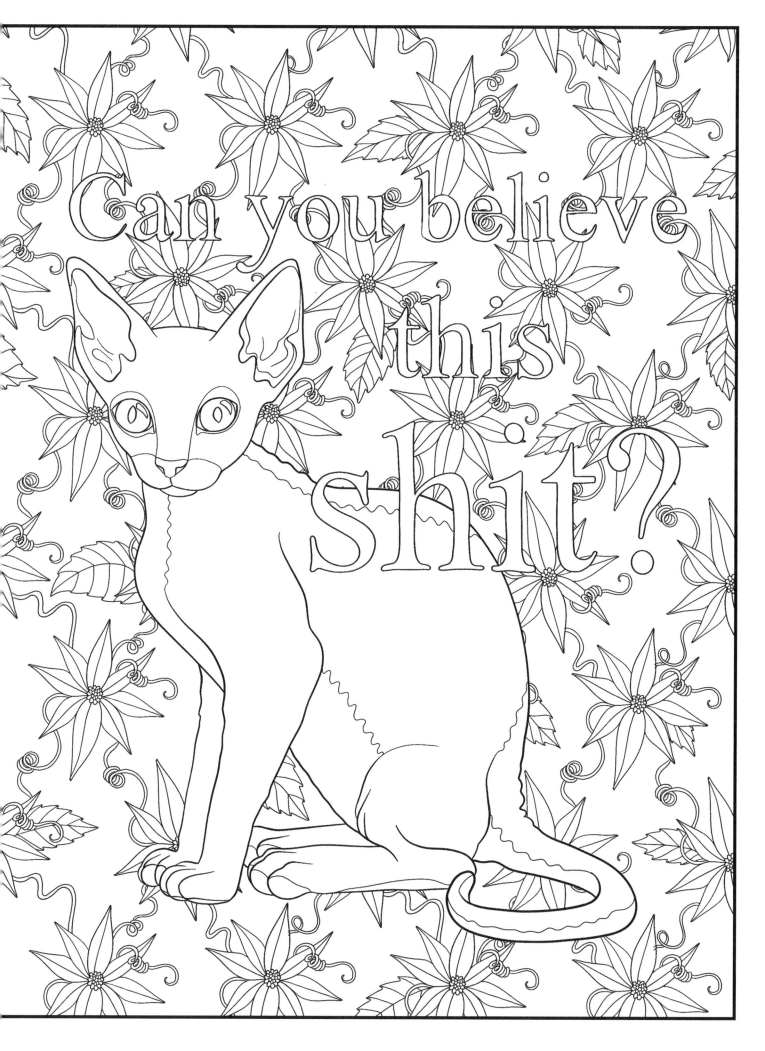

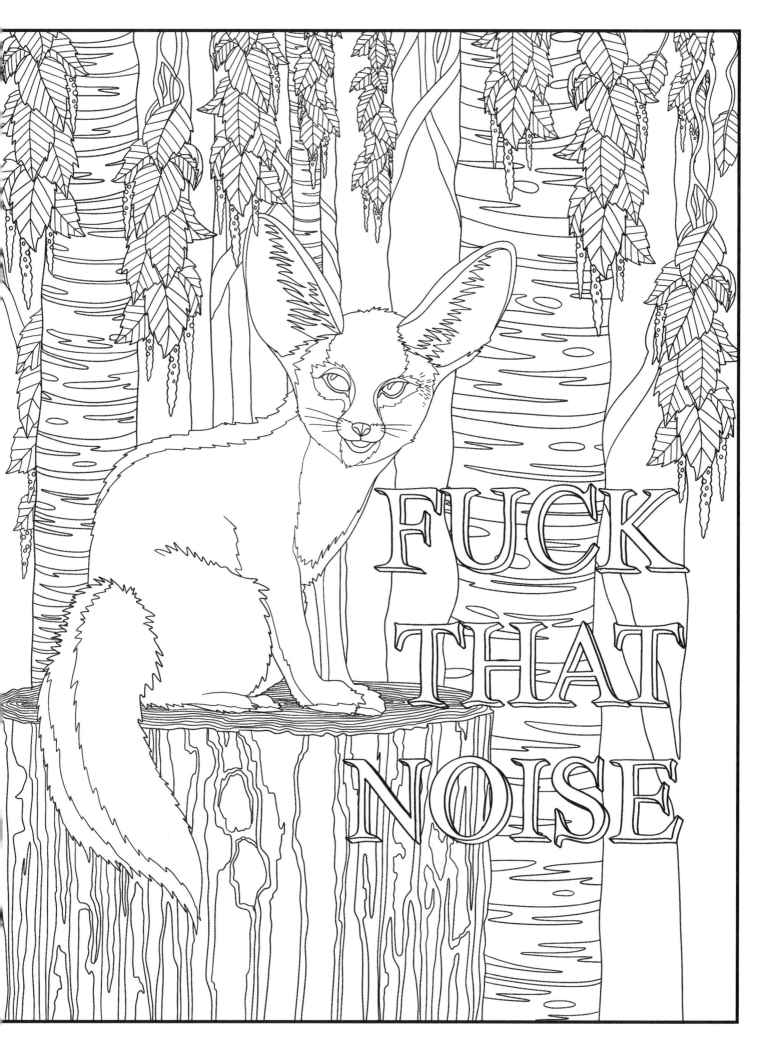

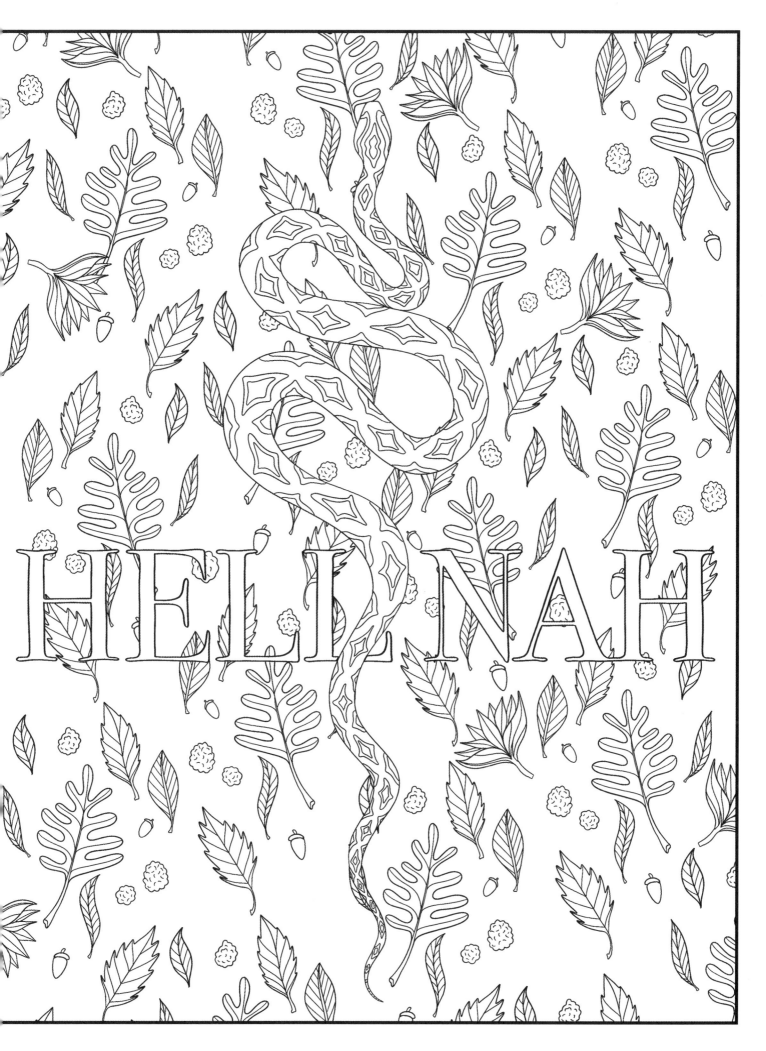

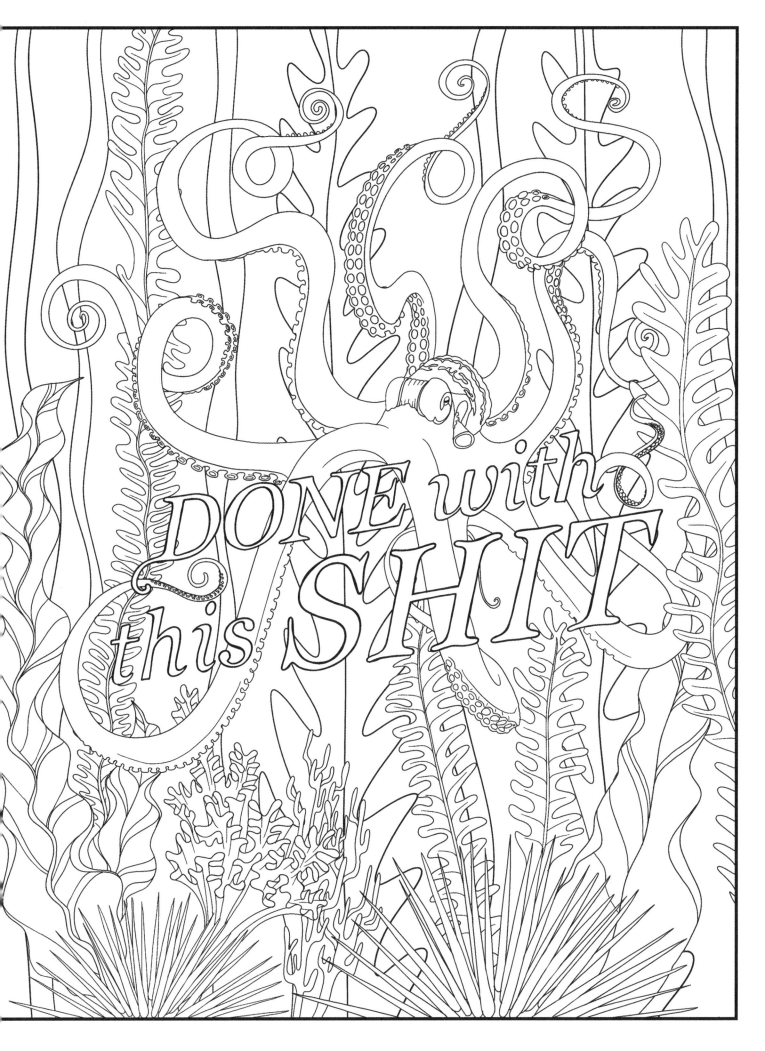

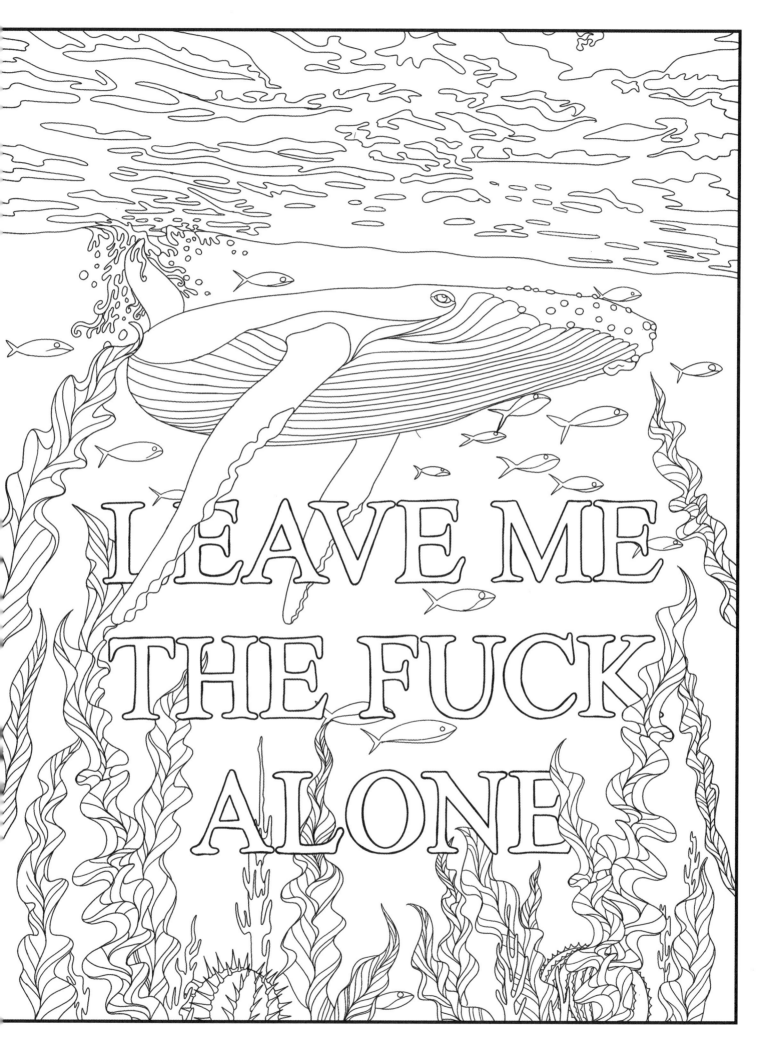

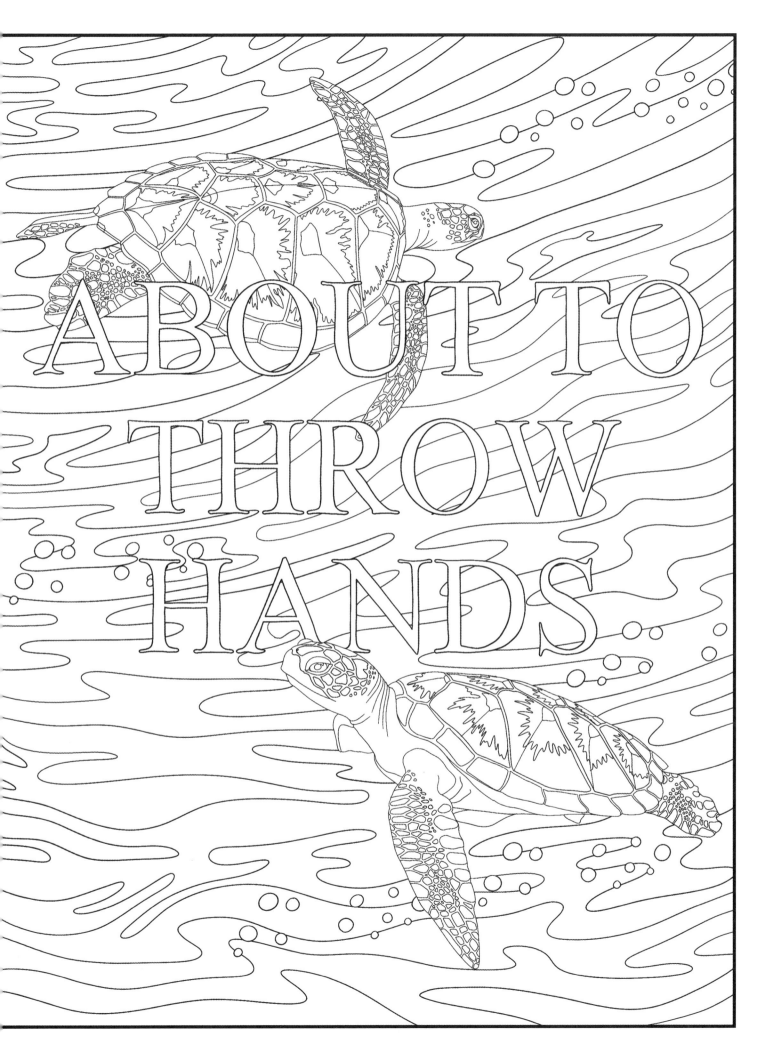

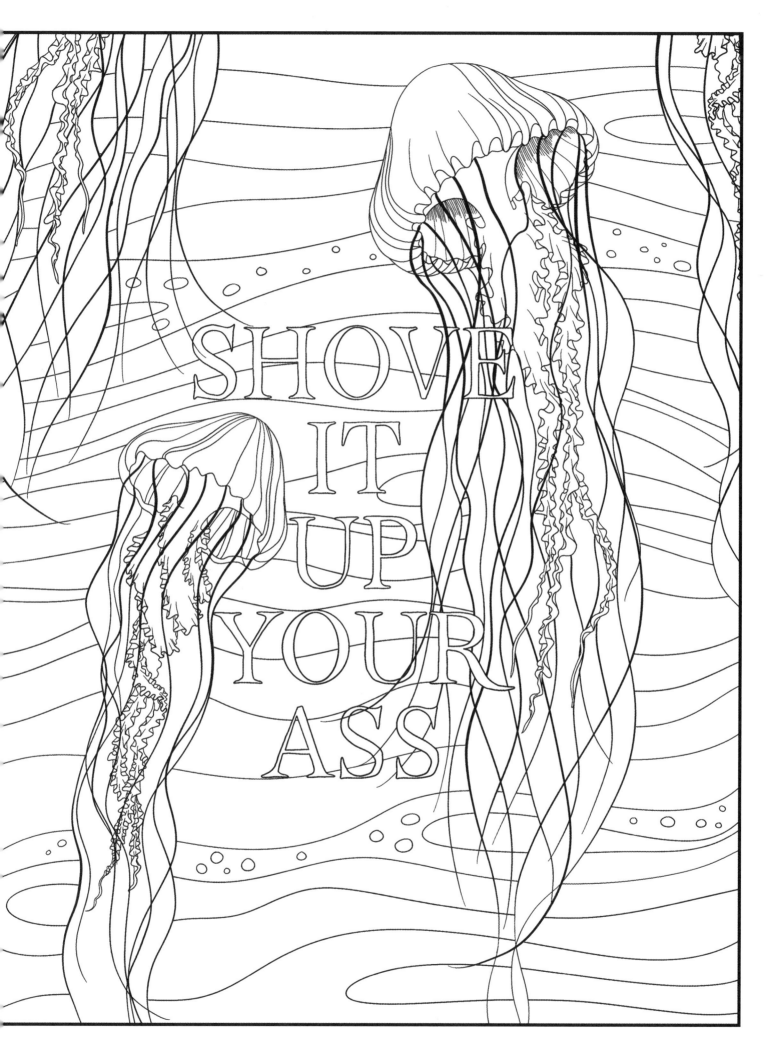

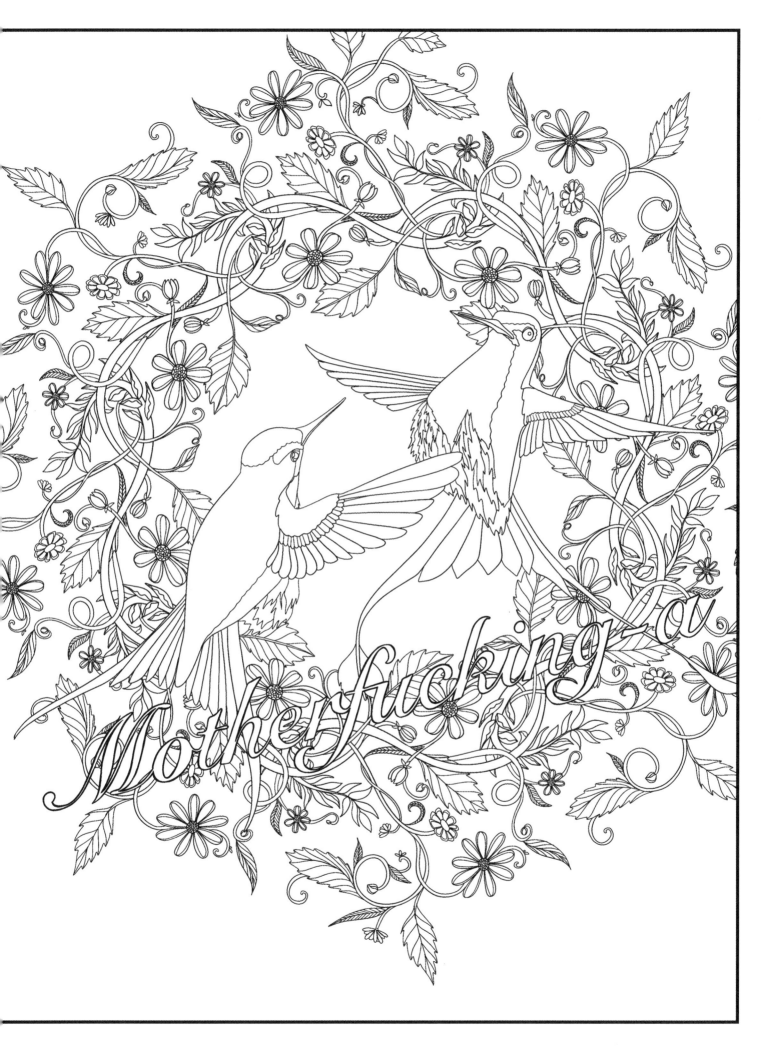

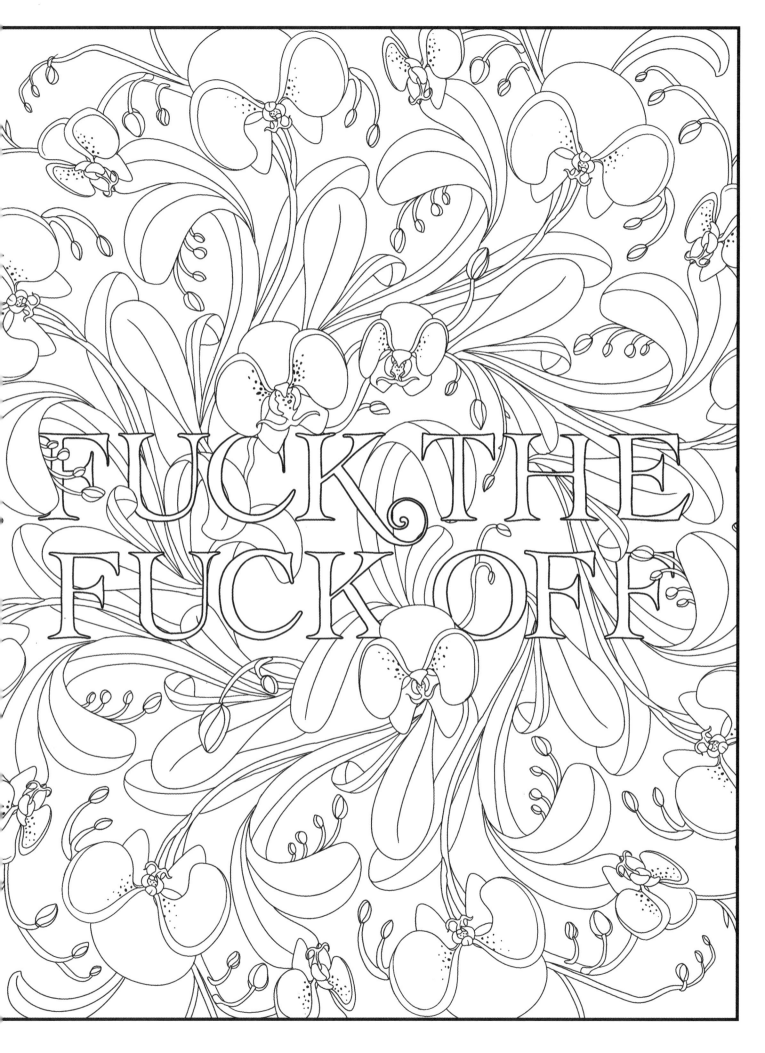

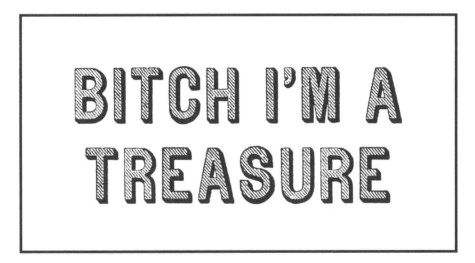

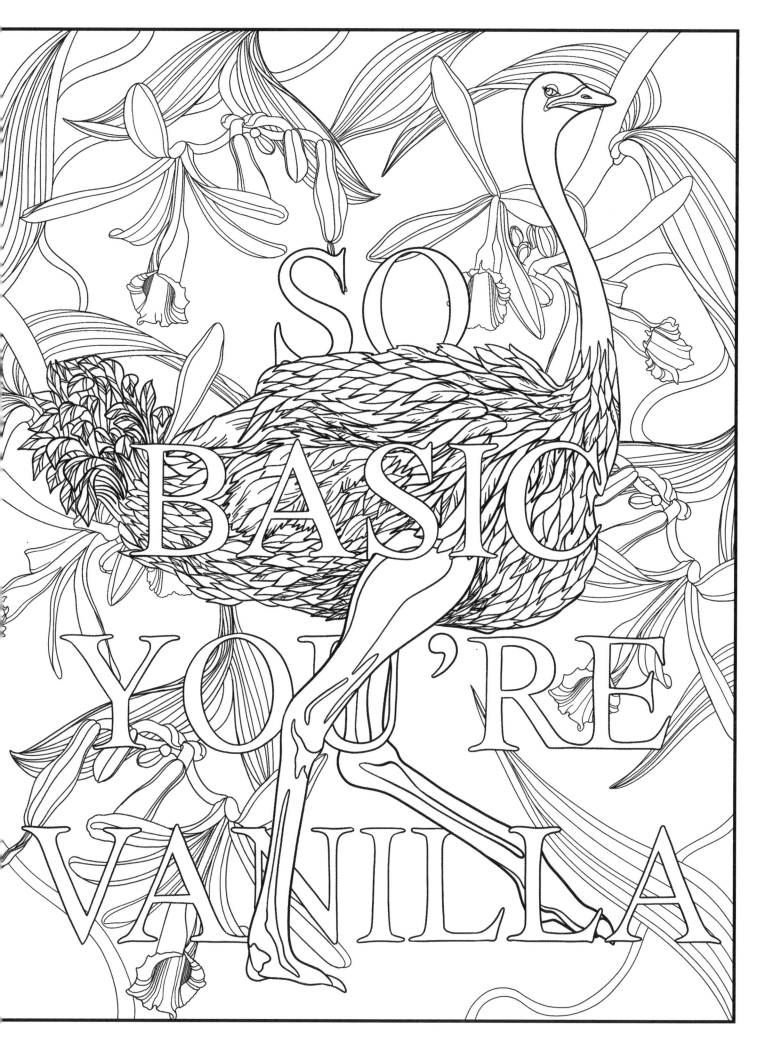

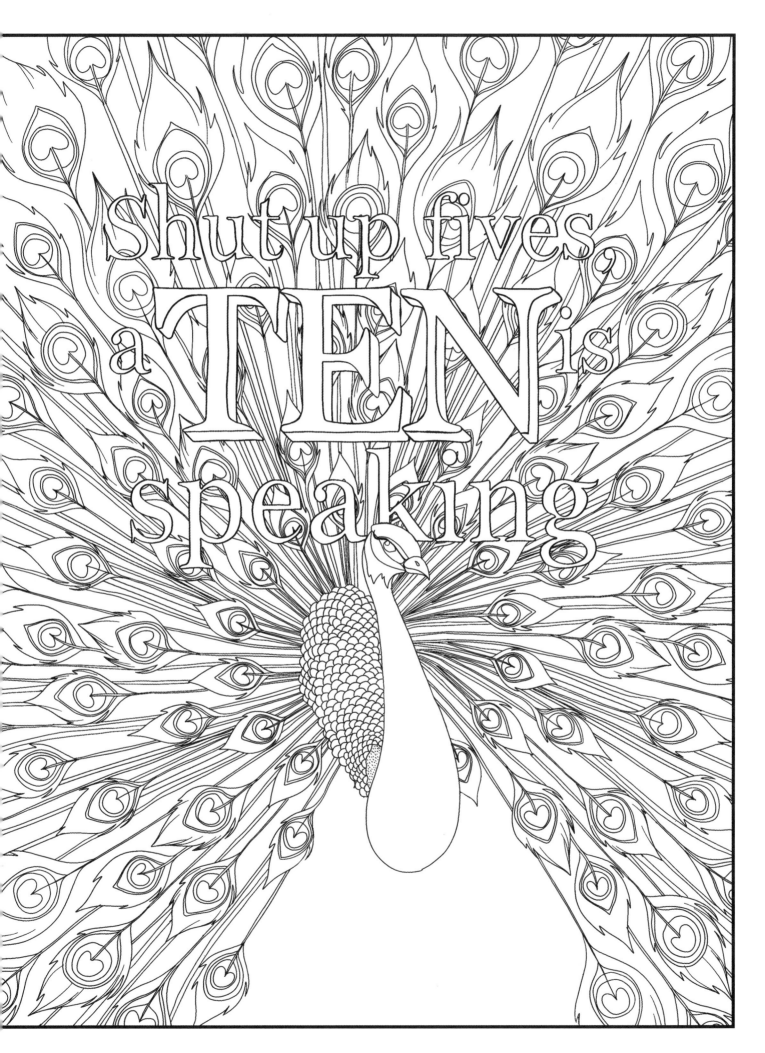

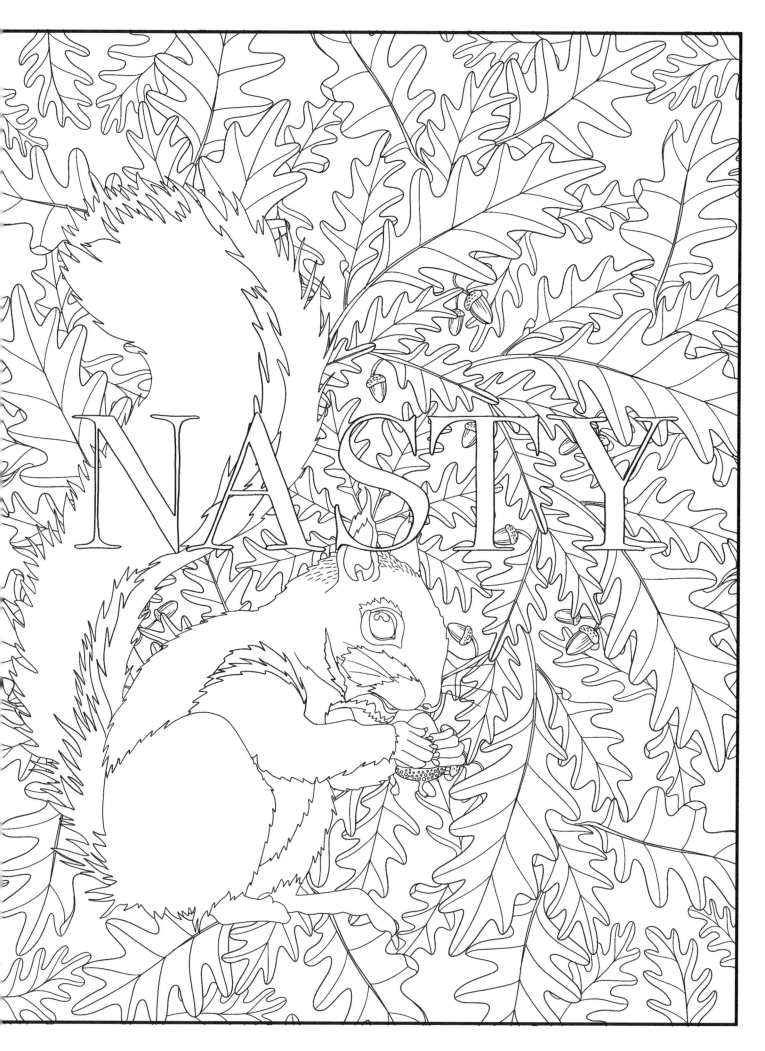

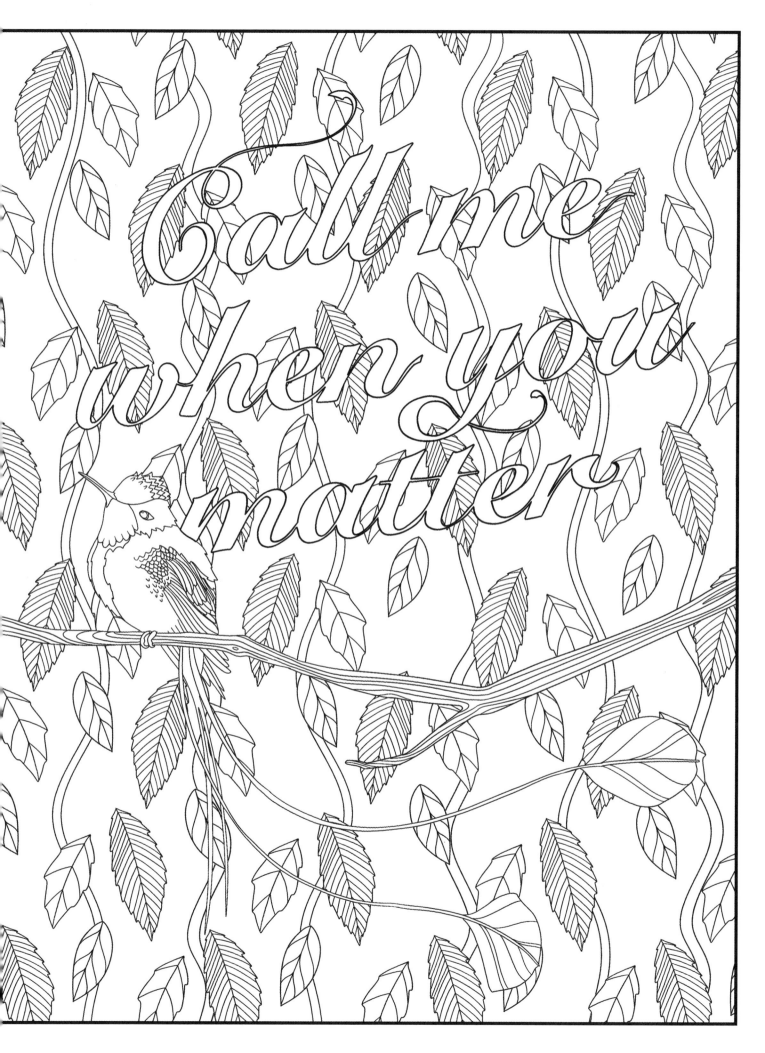

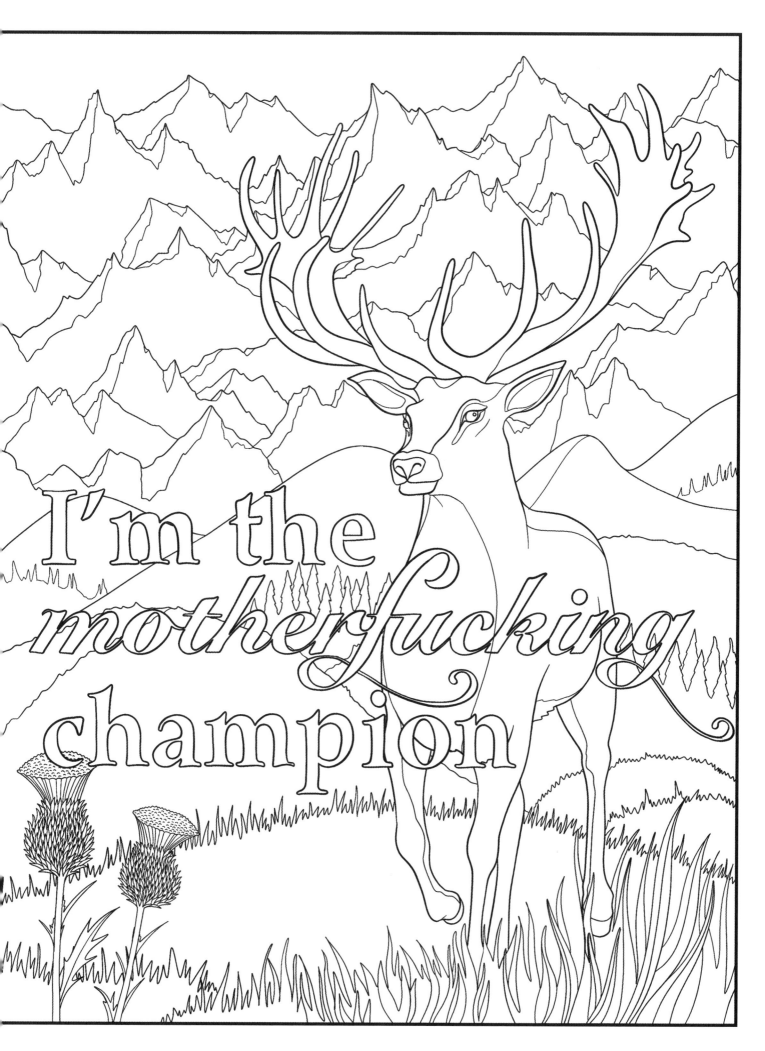

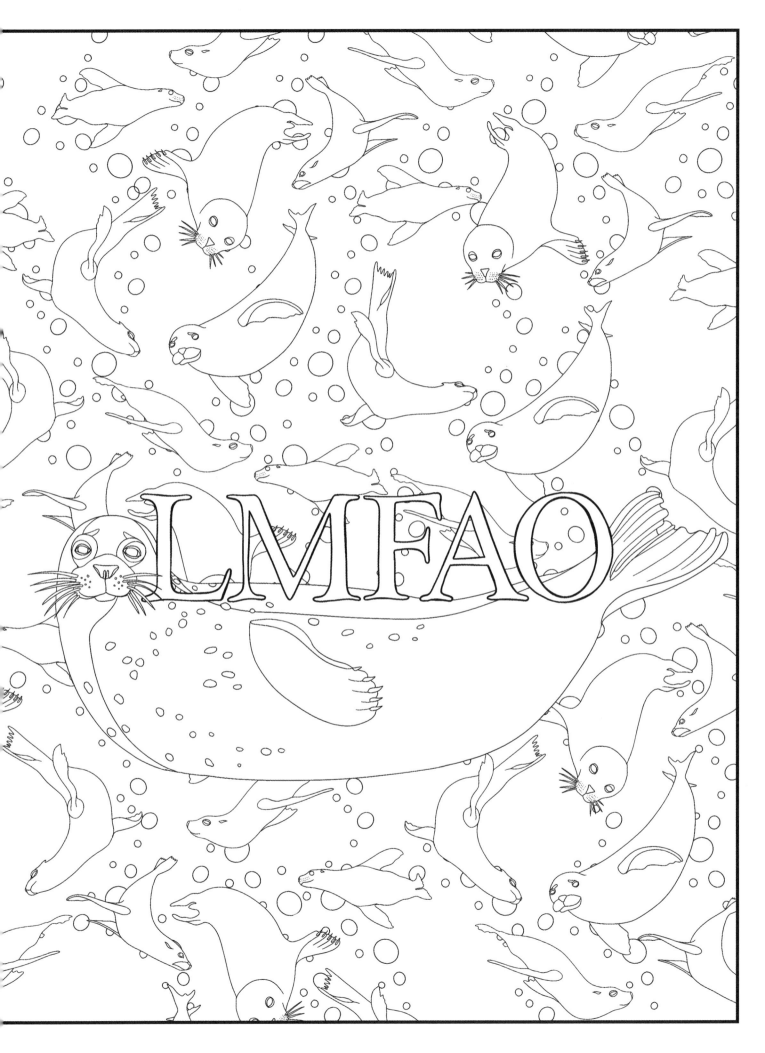

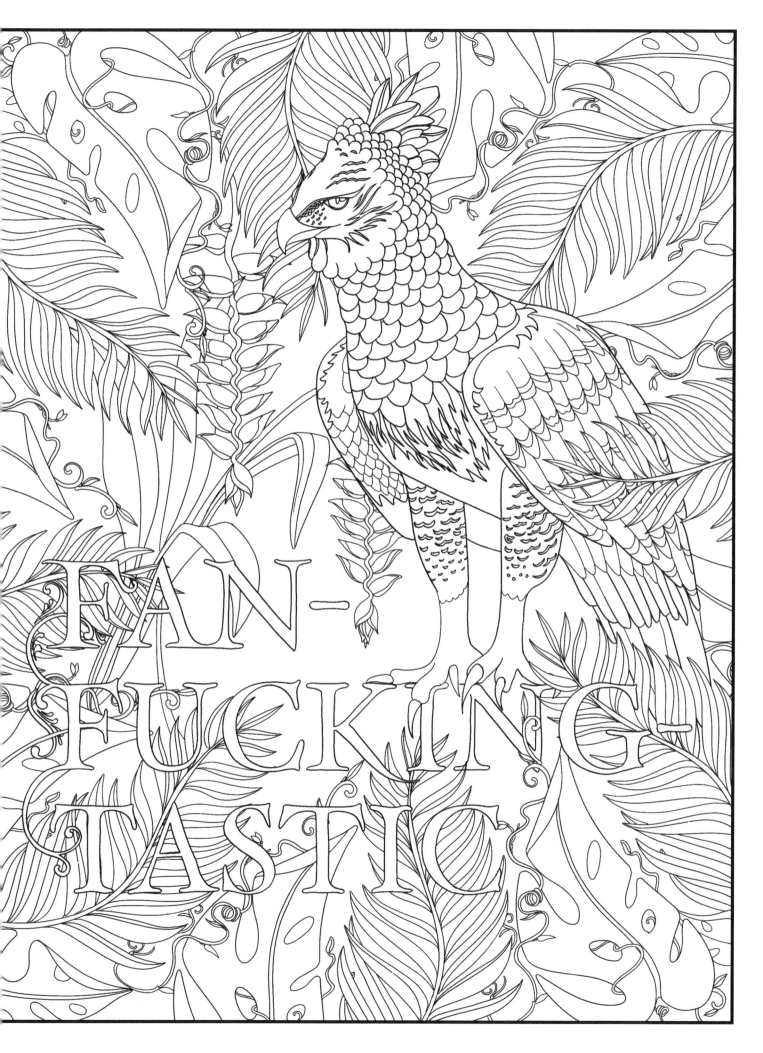

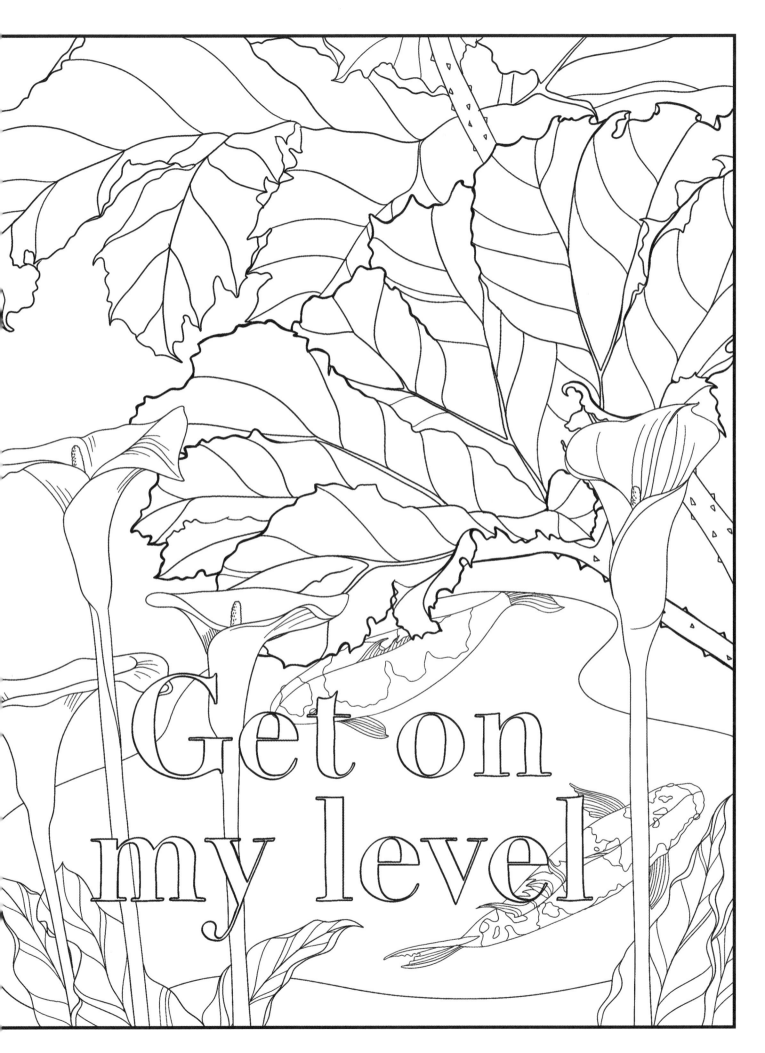

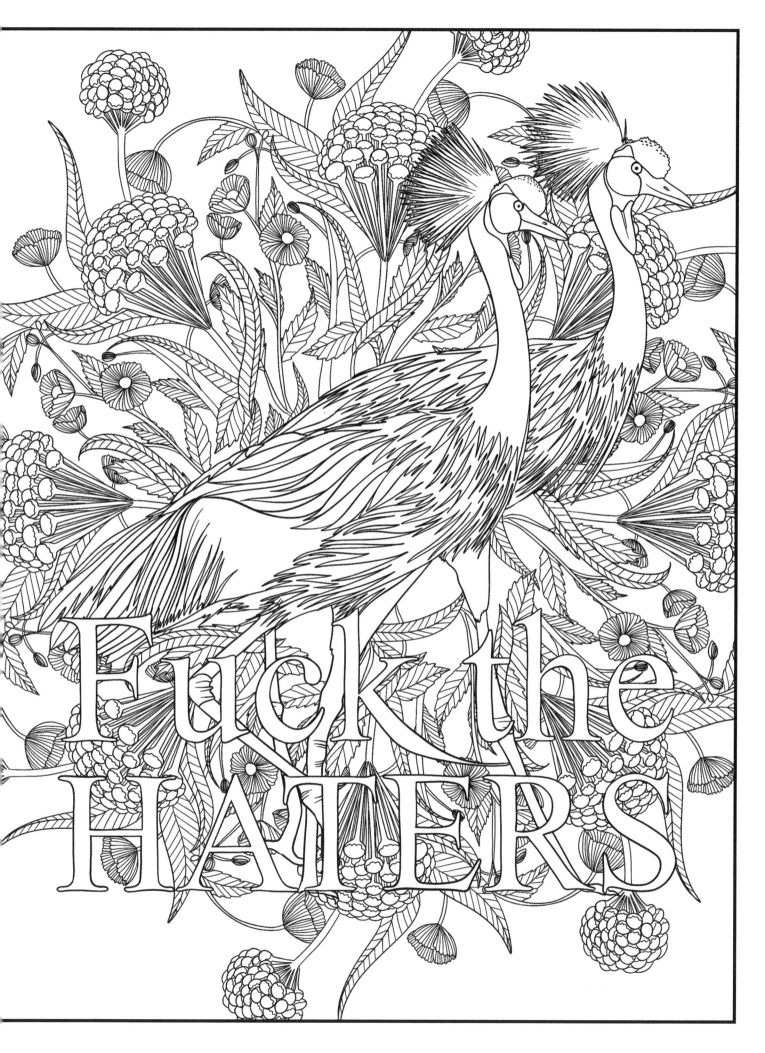

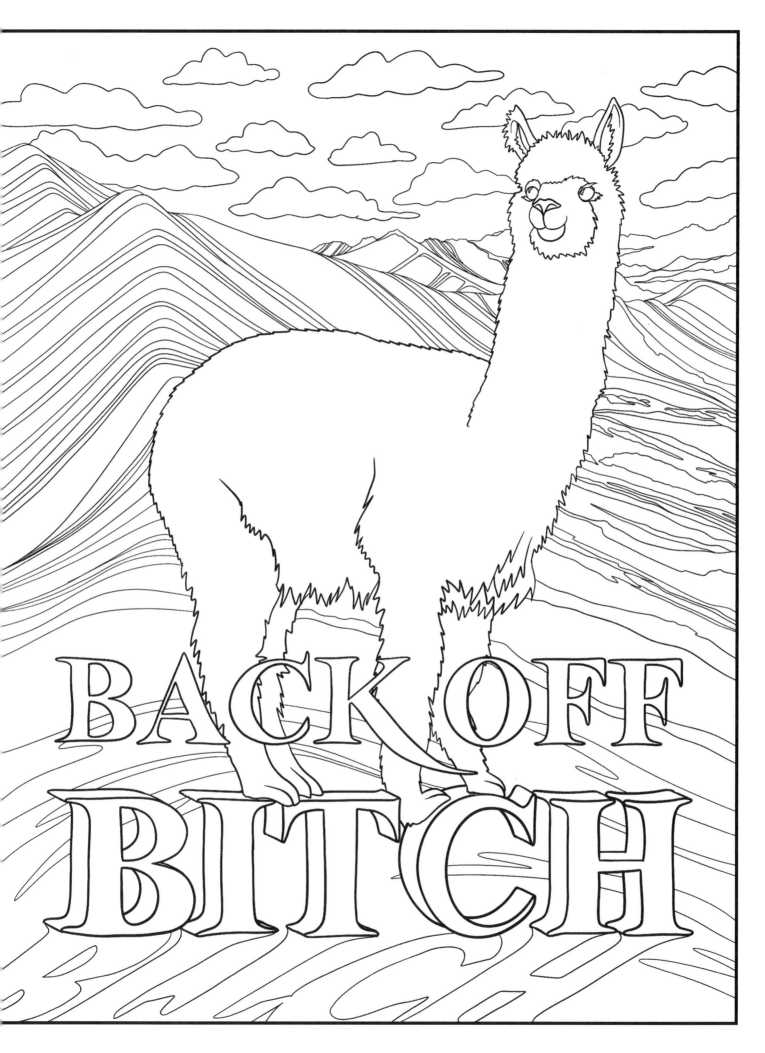

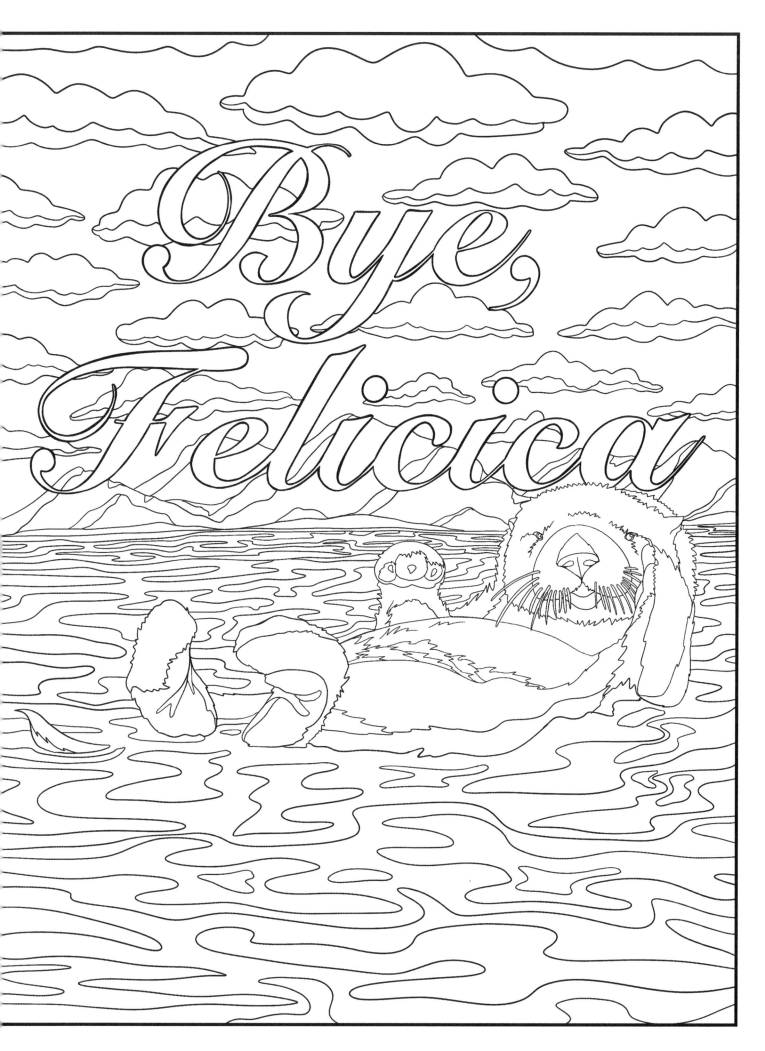

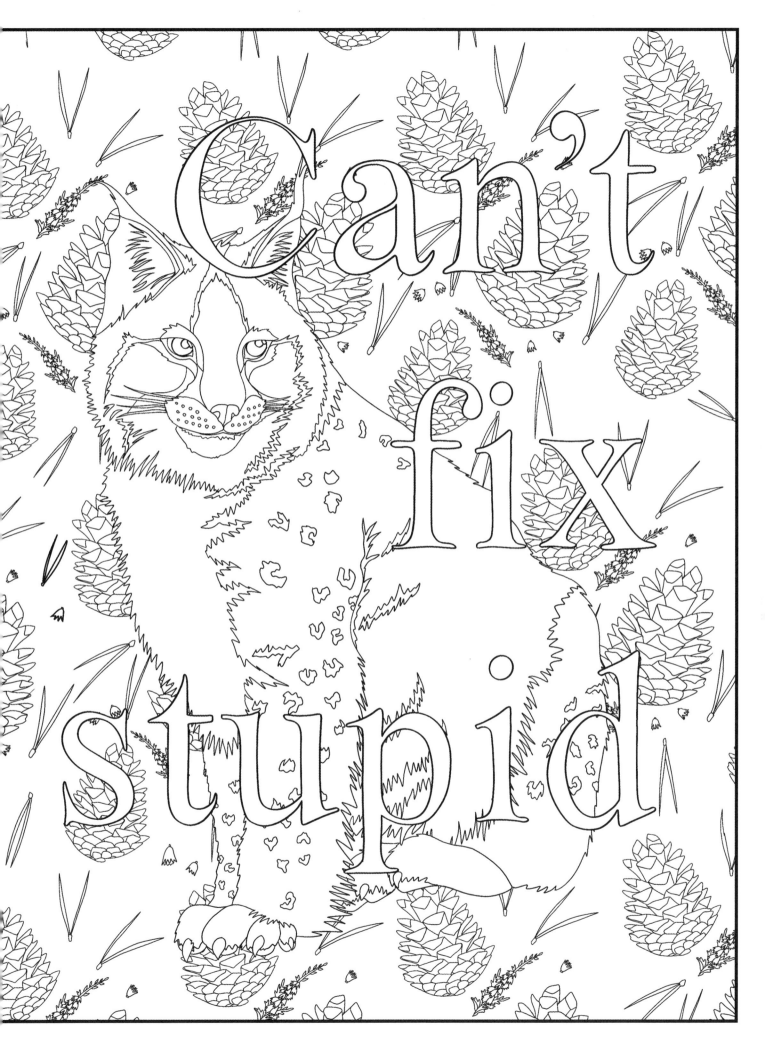

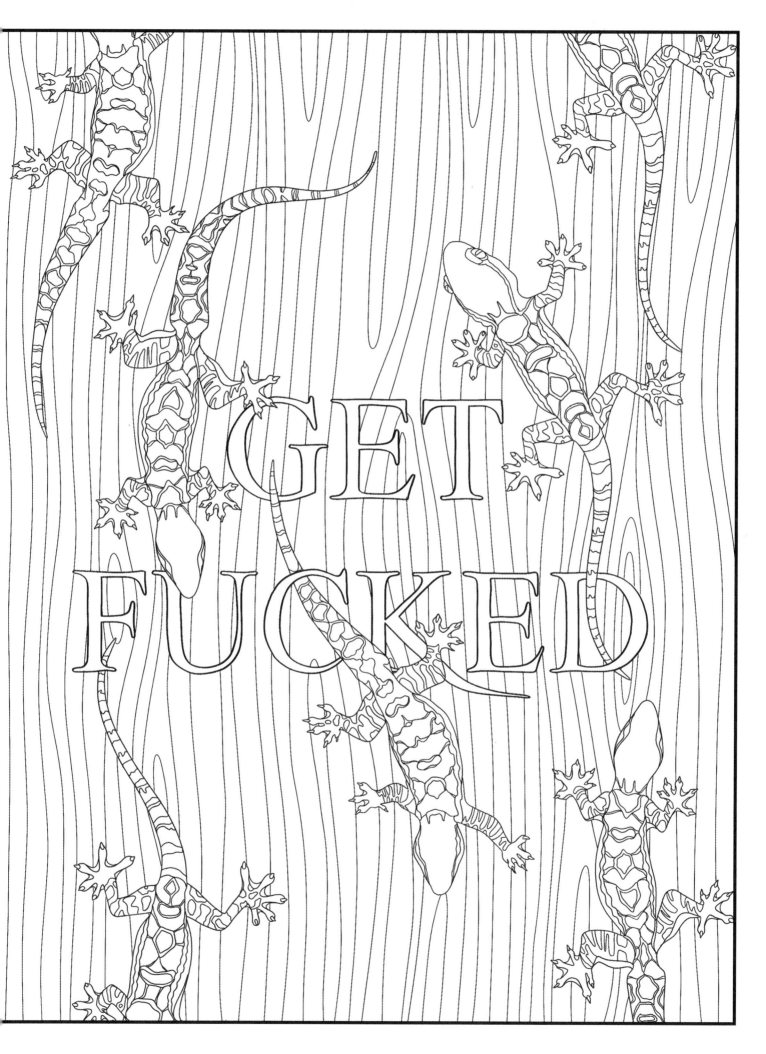

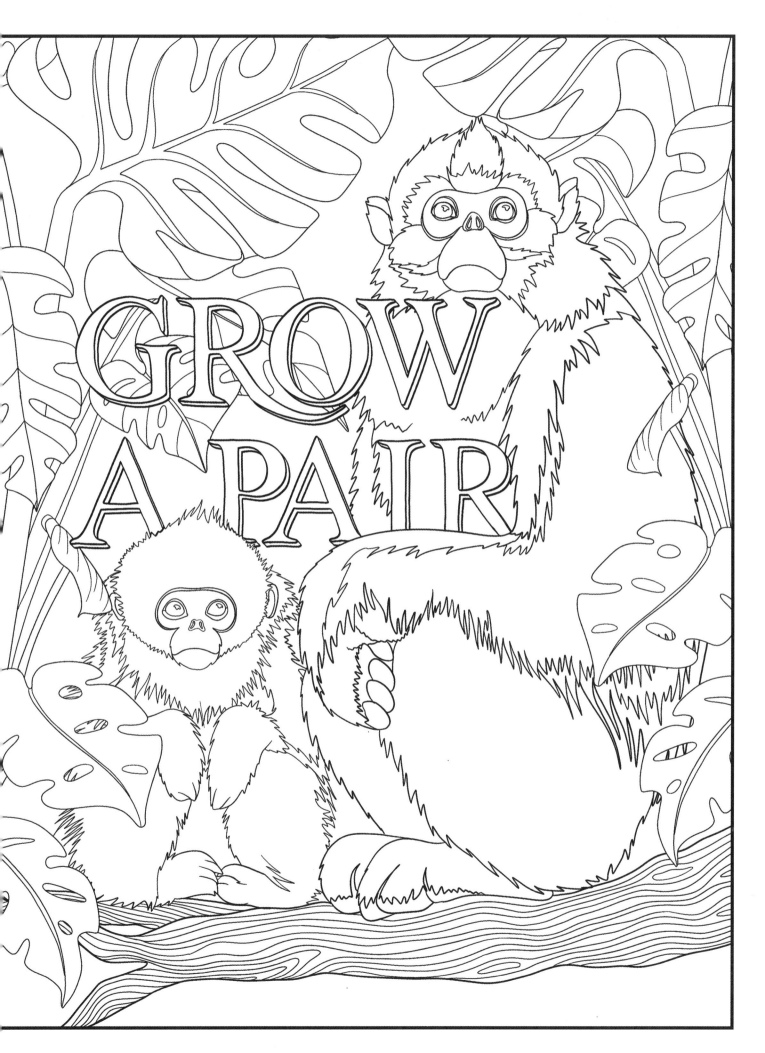

#FUCKOFFIMCOLORING #FUCKOFFIMCOLORING
#FUCKOFFIMCOLORING #FUCKOFFIMCOLORING
#FUCKOFFIMCOLORING #FUCKOFFIMCOLORING
#FUCKOFFIMCOLORING #FUCKOFFIMCOLORING
#FUCKOFFIMCOLORING #FUCKOFFIMCOLORING
#FUCKOFFIMCOLORING #FUCKOFFIMCOLORING
#FUCKOFFIMCOLORING #FUCKOFFIMCOLORING
#FUCKOFFIMCOLORING #FUCKOFFIMCOLORING
#FUCKOFFIMCOLORING #FUCKOFFIMCOLORING
#FUCKOFFIMCOLORING #FUCKOFFIMCOLORING
#FUCKOFFIMCOLORING #FUCKOFFIMCOLORING
#FUCKOFFIMCOLORING #FUCKOFFIMCOLORING
#FUCKOFFIMCOLORING #FUCKOFFIMCOLORING
#FUCKOFFIMCOLORING #FUCKOFFIMCOLORING
#FUCKOFFIMCOLORING #FUCKOFFIMCOLORING
#FUCKOFFIMCOLORING #FUCKOFFIMCOLORING
#FUCKOFFIMCOLORING #FUCKOFFIMCOLORING
#FUCKOFFIMCOLORING #FUCKOFFIMCOLORING
#FUCKOFFIMCOLORING #FUCKOFFIMCOLORING

SHARE YOUR BITCHIN' MASTERPIECES

Don't keep your colorful creations
to yourself—take a pic and share it
on social media with the hashtag
#fuckoffimdoingdottodot!

For more stress-relieving coloring,
check out *Fuck Off, I'm Coloring* and
Bite Me, I'm Coloring, available now!

INDEX

ABOUT
DARE YOU STAMP CO.

Dare You Stamp Co. was founded in 1776 when noted Philadelphian Jeremiah Dare was hired by the not-yet-Founding Fathers to print draft copies of the Declaration of Independence.

When the documents arrived at Independence Hall, an unfortunate typo read "When in the Curse of human events…"

So irate was George Washington that he said, "The foolish and wicked practice of profane cursing and swearing is a vice so mean and low that every person of sense and character detests and despises it."

Dare's instinct was to simply reply, "Fuck you."